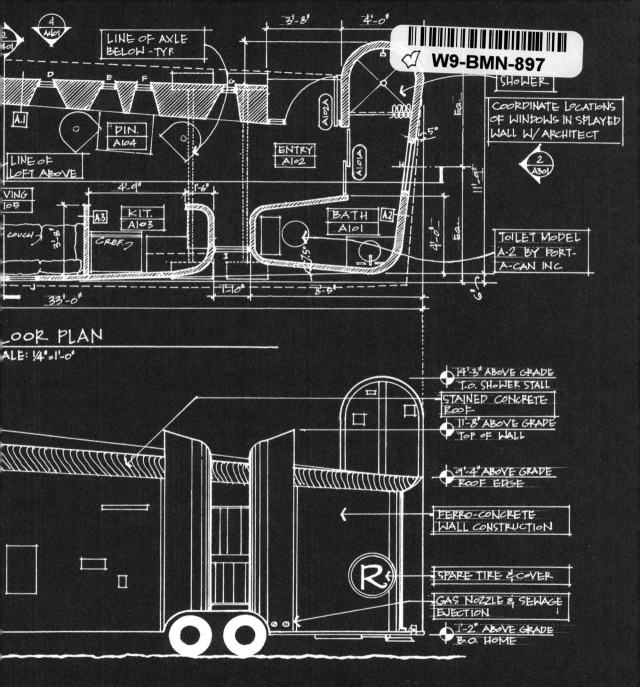

Mobile Homes
BY FAMOUS ARCHITECTS

TEXT AND RENDERINGS BY
STEVE SCHAECHER

PREFACE BY R. V. PARKE

Pomegranate

San Francisco

Published by
Pomegranate Communications, Inc.
Box 6099, Rohnert Park, CA 94927
800 227 1428
www.pomegranate.com

Pomegranate Europe Ltd.
Fullbridge House, Fullbridge
Maldon, Essex CM9 4LE, England

LIBRARY OF CONGRESS CATALOGING-IN-PUBLICATION DATA
Schaecher, Steve, 1967-
 Mobile homes by famous architects / text and renderings by Steve Schaecher ; preface
by R. V. Parke.
 p. cm.
 Includes bibliographical references.
 ISBN 0-7649-2024-3 (alk. paper)
 1. Mobile homes--Caricatures and cartoons. 2. Imaginary buildings--Caricatures and
cartoons. 3. American wit and humor, Pictorial. I. Title.

 NC1429.S356 A4 2002
 728.7'9'0207--dc21 2001056048

Pomegranate Catalog No. A628

Cover and interior design by India Ink, Petaluma, California

Printed in China

10 09 08 07 06 05 04 03 02 10 9 8 7 6 5 4 3 2 1

Contents

Preface

I don't know about you, but architecture has always moved me. Ever since I was knee-high to a praying mantis, I understood that architecture could be moving, and, in fact, should be moving.

I was lying in my crib with the sounds of Billy Ray Buffalo's Big-Time Buckwheats lulling me to sleep when I first became aware of a gentle, rolling motion. Then I saw that the tree which had been outside of my window wasn't there anymore. Then I saw a new tree appear. Then that one disappeared, too. My first memory of hitting the road.

My parents (I later learned) were relocating to an even-more-east section of the great state of Texas, and guess what: we didn't even have to pack! My siblings and I just went on with our normal day as usual, although, of course, we couldn't step outside for a romp around the yard. It was that experience, of life going on as normal while our house actually moved across the landscape, that convinced me—through and through to my very heart and soul—that architecture should move us all, and I've been writing about it ever since. (You can find some of my previous essays in the quarterly publication *Architecture: Then and Now; Here and There*.)

Why is moving architecture limited to domiciles, is what I'd like to know. Consider the following scenarios:

MOBILE MUSEUMS. If you put the Metropolitan Museum of Art on wheels, just imagine how many more people would have the opportunity to see all that great art! Art should be moving, too, after all.
MOBILE CATHEDRALS. Notre Dame, now, has to stay in Paris *all the time*. Um, *duh!*
MOBILE CAPITOL. Hey, if all those congresspeople moved around the country all day instead of sitting in one building, don't you think they would be more responsive to their constituents? You bet they would! It's kind of hard to hide from people when you're in the middle of everywhere!

The designs of houses by the famous architects represented in this book should be enough to convince you, too, that architecture should not be limited by site and place. These great minds have put their best efforts toward creating a truly mobile society in which aesthetics never take a back seat to function. Now even the rich can enjoy the lifestyle to which they have become accustomed and still see the country from the safety of their own back porch. Talk about upwardly mobile; jeesh. And, hey, no more jokes about trailer parks and tornadoes, and East Texas divorces and all that prejudicial hogwash! Wake up! Just because you might not enjoy living out in the flats in 100 degree heat doesn't mean that you're better than us! And what business is it of yours anyway who gets what in a divorce! And tornadoes are no laughing matter, either, dammit!

But I digress.

I'll just leave you with this thought: Good architecture is important. Moving is important. It doesn't take a Saab repairman to put the two together and understand that two birds in the bush equal one helluva ride.

—R. V. Parke

About the Author

STEVE SCHAECHER

A practicing architect in Indianapolis, Steve Schaecher began a moonlighting career in cartooning with a strip titled *Oblique View,* which focused on humor in architecture. He then published a deeply theoretical book about design called *Outhouses by Famous Architects* (Pomegranate, 2000).

Although not engaged in any intelligible architectural philosophy, Schaecher has managed to seek out the whimsical side of his profession. He believes that architecture is becoming a lost art, diminished by the fast pace of technological change and the lawsuit-conscious construction industry. His focus is to entertain the masses while also providing a little education about and exposure to architecture.

Schaecher currently resides in Speedway, Indiana, with his wife, Susie, and children, Nathan and Lindsey. He can be reached at his website www.dipahead.com.

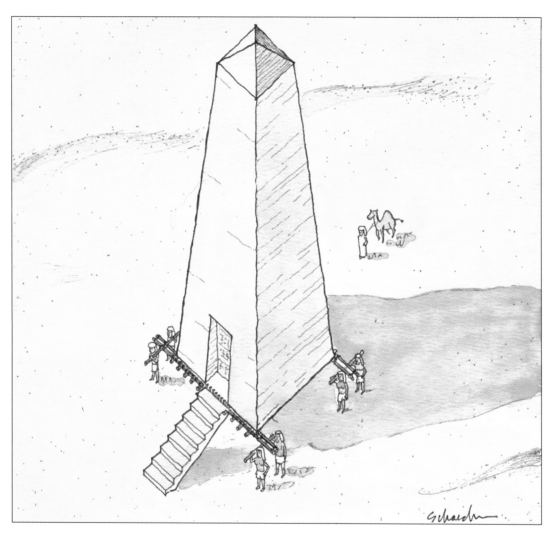

Mobilisk

The Egyptians

C. 3200 B.C.–1085 B.C.

The Egyptian culture was highly significant in many respects. The Egyptians were responsible for creating the earliest—and only surviving—wonder of the Seven Wonders of the Ancient World: the Pyramids. Egyptian art, architecture, and hieroglyphics continue to fascinate the world and encourage us to learn more about the society from which they arose.

Guided by a complex system of religious beliefs, Egyptian society focused on its leaders, the pharaohs, believed to be divine; its architecture sought to provide for the divinities in life and death and to match the grandeur and vastness of its physical surroundings: the Nile River, the mountains, and the great North African desert.

Travel throughout the desert was not easy. To properly accommodate their royalty, Egyptians became the first society to develop the mobile home, or Mobilisk. These dwellings resembled the Egyptians' monuments to their gods, but they were equipped with all the ancient-day conveniences: a harem, a grape holder, and plenty of locust repellent. Slaves were used as the wheels for these homes. It was an honor for a slave to be selected for this role, because it assured ascension into the afterlife. Studies of certain hieroglyphics reveal that these homes were not used extensively because they were usually destroyed when one of the wheels failed.

mobile homes
by famous architects

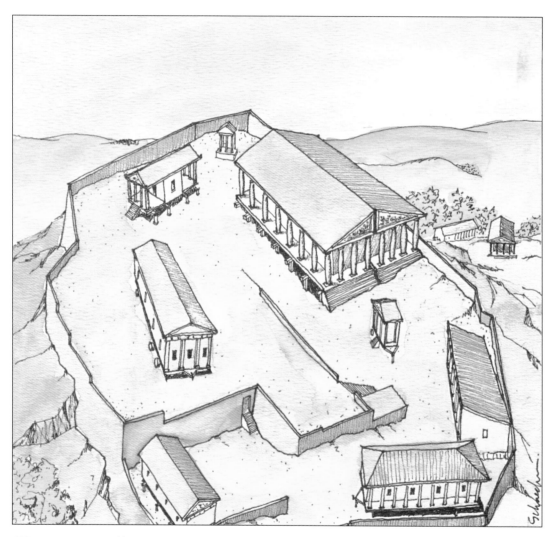

Parcopolis

The Greeks

C. EIGHTH CENTURY–FOURTH CENTURY B.C.

Greek architecture has been studied and interpreted throughout history. The diverse ancient culture created spectacular monuments to the gods. Utilizing the proportions of the golden section and developing the classical orders of columns—Doric, Ionian, and Corinthian—the Greeks' buildings achieved a grace and refinement that would be widely imitated.

The Parthenon is one temple that stands above the others. Located at a complex called the Acropolis in Athens, this monument exhibits the perfect simplicity and harmony that defined Greek architecture. The tilt and tapering of the columns reflect a remarkable awareness of optical distortions. Filled with exquisite sculpture on a grand scale, this was the High Temple of Greece.

On the south side of the Aegean Way stood another complex equal in grandeur. Called the Parcopolis, this group of pull-temples was often relocated to preserve its sacredness from frequent invasions by marauders. Many historians believe that the skewed relationships of the buildings were the Greeks' effort to provide perfect perspective views of their facilities. In the case of the Parcopolis, artifacts have been found indicating that the buildings were simply placed where their owners' horses expired.

mobile homes
by famous architects

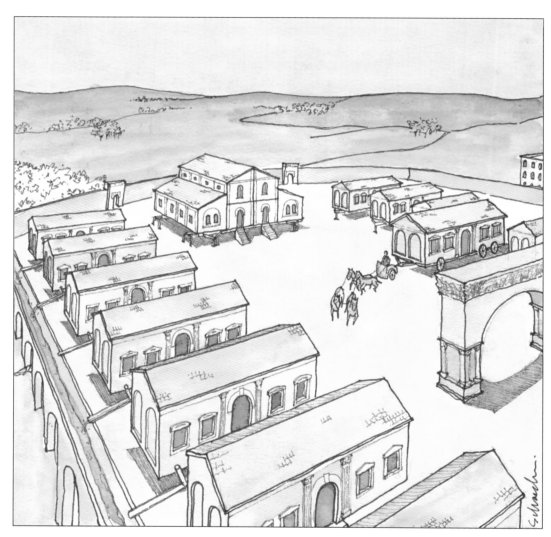

The Imperial Forum Trailerini

The Romans

C. EIGHTH CENTURY B.C.–FOURTH CENTURY A.D.

The Roman era was marked by significant cultural, political, and architectural achievements. Owing much of their culture to the Greeks, whom they had conquered, the Romans developed a flourishing society with innovations in industry, commerce, shipping, roads, and urban design (think aqueducts). Roman architecture expanded the artistic qualities and proportions the Greeks had established.

Roman resourcefulness provided new means of expression in architecture. The arch and barrel vault contributed breakthrough structural methods to achieve greater heights. And the Roman development of concrete opened the door to many original construction possibilities.

Although not as architecturally prominent as the Roman monuments, the Imperial Forum Trailerini is significant for its functional ingenuity. Intended to promote commerce throughout the empire, this forum was a popular place to reside in, temporarily or permanently. The Trailerini was equipped with sewer aqueducts to which users could easily attach their RVs' outflow systems. Architecturally, the Trailerini served as a testing ground for new designs, which were periodically substituted for preexisting trailers. The area was visited often and was a bustling hub of commerce. Later it was commemorated with the Arch of Chariotus II.

mobile homes
by famous architects

PAGE

11

OF 64 PAGES

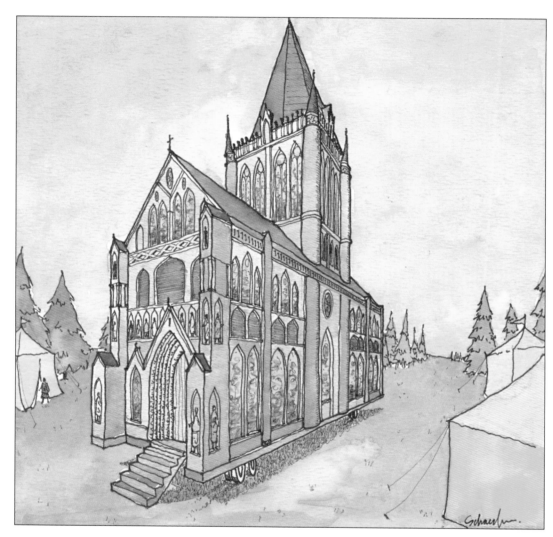

Salisbury Cathed-roll

Gothic

C. 1100–1400 A.D.

The term "Gothic" was coined by Renaissance thinkers to describe the art and architecture of the preceding period. They viewed that time as a "dark age" when invading tribes of Goths laid waste to Roman art and culture. However, the Gothic period was later valued for the freedoms and magnificence that it presented to the architectural world.

Gothic architecture broke from the tradition of classical architecture. It soared to new heights utilizing skeletal structural systems that tended to reduce mass, allowing a building to become an elegant configuration of form through voids and solids, lit by elegant stained glass windows. These structures seemed to reach toward heaven, or to provide a pathway to glory.

This age was also resented by Renaissance thinkers because of its introduction of evangelism. The Goths had decided that their new churches were so magnificent that they should be taken throughout their new empire to convey the word of the Lord. Although these Cathed-rolls appeared much lighter than their Roman predecessors, they were still immensely heavy and left deep, irreparable ruts in the paths they took.

mobile homes
by famous architects

PAGE

13

OF 64 PAGES

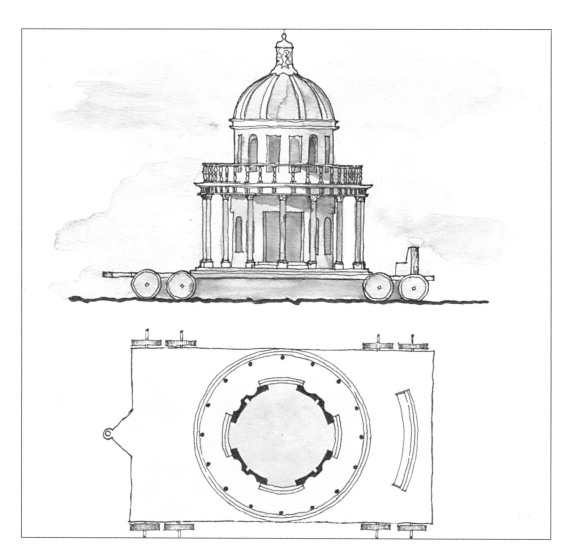

Traileretto

Donato Bramante

BORN 1444, MONTE ASDRUALD (NOW FERMIGNANO), ITALY

DIED 1514, ROME

Bramante studied painting under Mantegna and Piero della Francesco. He moved to Rome in 1499, where he caught the eye of future Pope Julius II. The Pope later hired him to renew the Vatican complex.

Experiencing the antique monuments of Rome led Bramante to restore the architecture of the time to its former nobility and might. He developed architecture that would be attractive from all sides. Walls were treated three-dimensionally as sculpture in the round; in them he placed deep niches. Bramante manipulated architecture to provide illusory effects more typically used in stage settings. This development led to the Mannerist Style.

Bramante's most notable work is the Tempietto outside St. Peter's Cathedral. This work was so outstanding that the Pope commissioned a mobile replica to parade through the Vatican and the rest of the Roman Empire. The Pope began to use the Traileretto as a vehicle to reach the masses. In essence, it was the first Popemobile.

mobile homes
by famous architects

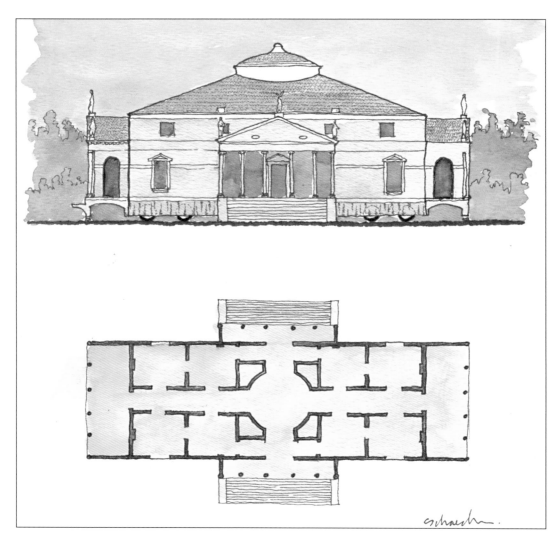

Villa Tornadio

Andrea Palladio

BORN (ANDREA DI PIETRO DELLA GONDOLA) 1508, PADUA, ITALY

DIED 1580, ROME, ITALY

Apprenticed to a stonecutter at the age of thirteen, della Gondola became an assistant in a stonecutting shop in Vicenza. He later met an amateur architect named Trissino, who helped educate him. Trissino renamed him Palladio, after the Greek goddess of wisdom. Palladio went on to publish *I Quattro libri dell' architectura*, outlining his principles and giving practical advice for builders.

Palladio was one of the most influential architects of the Western world. His works (typically homes) were precise, carefully propor-tioned, classical buildings. All profoundly symmetrical, they recalled Greek and Roman temples—only now the temple was for man, not a god. Palladio's works came to embody the thoughts of all Renaissance works, to revive and interpret antiquity.

Originally named the Villa Rolltunda, Palladio's mobile home suffered a series of unfortunate incidents in Italian storms. After the home was rebuilt for the fifth time, Palladio decided to name it after its nemesis. The drawing of the home is an artist's interpretation of how the house may have looked. Villa Tornadio was destroyed, along with all records of its design.

mobile homes
by famous architects

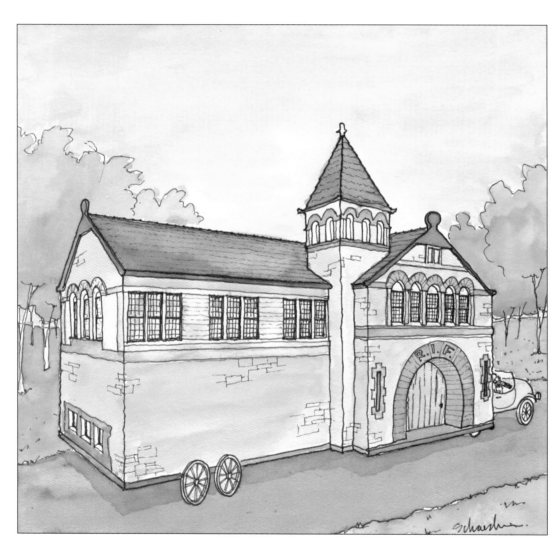

Ames Horse-Free Pull-Library

Henry Hobson Richardson

BORN 1838

DIED 1886

Richardson graduated from Harvard University in 1859 and then attended the École des Beaux-Arts in Paris. He became one of the first American architects to have real influence throughout the world, especially through his innovative uses of fine materials.

Incorporating the principles he had learned in Paris and the United States, Richardson developed his unique style, soon dubbed Richardsonian Romanesque. Its characteristic elements were round arches, rusticated masonry, and colonnettes. The massing for his buildings was logical and asymmetrical—an indication of his French schooling. However, the richly textured colors of his designs reflected High Victorian influences.

Richardson worked in many building types, including libraries. His design for the Ames Library became one of his most notable works. It was so successful that the library instituted the outreach program R.I.F. (Reading Is Fundamental). Richardson succeeded again, creating a stately mobile facility that exhibited the sound principles embodied by its parent library. The Ames Horse-Free Pull-Library became the inaugural Bookmobile; it has helped bring books like this to readers everywhere. Thanks, H. H.

mobile homes
by famous architects

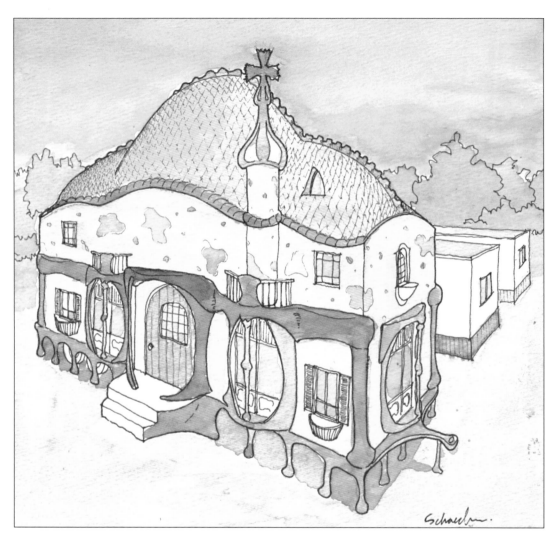

Cart a Bung'lo

Antonio Gaudi

BORN 1852, REUS, SPAIN

DIED 1926, BARCELONA

The son of a coppersmith, Antonio Gaudi studied architecture at Escola Superior d'Architectura in Barcelona. His work is classified as Art Nouveau, but it really extended beyond the classification through its organic and fantastical forms.

Gaudi adopted the doctrine of architectural theorist Éugene Viollet-le-Duc, who called for "organic rationalism" in design and compared architecture to the functionalism of a tree or an animal's skeleton. Gaudi applied these thoughts in a literal fashion, producing geomorphic designs that escalated the structures to a primal, visionary world of Expressionism.

With his mobile home design, Gaudi's expressionism was at full realization. His image for the home was a tortoise-like creature that had crept into the trailer park. His original design had functional legs that literally allowed the home to crawl. After authorities confiscated his stash, he realized the impracticalities of this design and succumbed to the conventional axles and wheels. Although not as natural as his original concept, the Cart a Bung'lo provides a great security service for its park because of its mythological beast appearance.

mobile homes
by famous architects

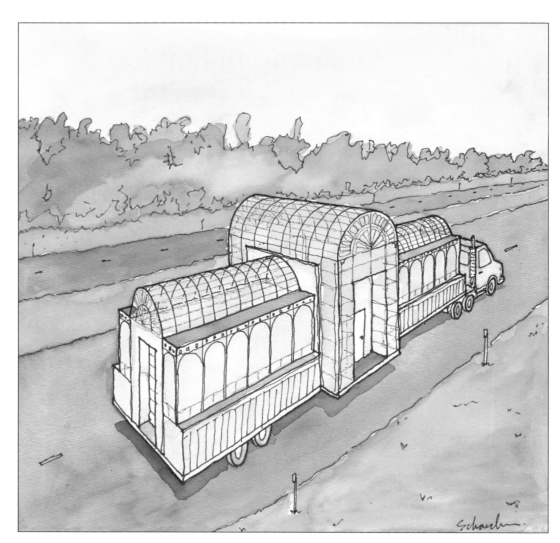

Crystal Haul-Palace

Joseph Paxton

BORN 1801, MILTON BRYAN, ENGLAND

DIED 1865, SYDENHAM, ENGLAND

A farmer's son, Paxton became a prominent gardener for the Duke of Devonshire at Chatsworth, where he developed an expertise in greenhouses and their construction. Ultimately he was commissioned to design the Crystal Palace, which became a monument to industrialism.

The magnificence of the Crystal Palace was not its form as much as its grandeur and the streamlined industrial processes of its manufacture. Constructed for the London Exposition of 1851, the building covered eighteen acres, was 1,851 feet high at its peak, and utilized roughly 900,000 square feet of glass. Its realization took just over four months and was a simple matter of mass production and systematic assembly. The building became a symbol of the achievements of the age.

To boastfully display their industrial superiority, the Brits constructed a mobile version of the palace to roam the highways of other countries. Like the original, the Crystal Haul-Palace enlightened its visitors to the effects that could be achieved with glass, steel, and uniformity. Some countries resented this manifestation of British pride and forced the exhibit to tour on bumpy gravel roads.

mobile homes
by famous architects

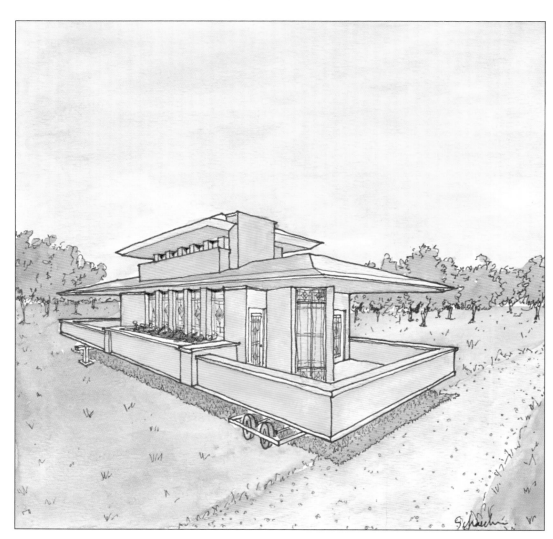

Robie Road Abode

Frank Lloyd Wright

BORN 1867, RICHLAND CENTER, WISCONSIN

DIED 1959, TALIESIN WEST, SCOTTSDALE, ARIZONA

By far the most famous American architect, Wright entered the University of Wisconsin in his teens—to study engineering, since architectural courses were not offered there. After a few semesters, he left to work under J. L. Silsbee and, later, Louis Sullivan. In 1893 he started his own practice.

Wright's career lasted seventy years, with more than eleven hundred buildings. Although there are distinct differences between his early and later work, his principles of design are evident in them all. Wright consistently emphasized the horizontal plane and architecture's connection to the organic. His early works utilized a cross-axial plan; they were mostly open, but—because of their configuration and abstraction—were separate.

One of Wright's early masterpieces was the Robie House. Once Mr. Robie retired, he and his wife decided to shed the cold weather of Chicago and pursue the American dream of traveling the country with a trailer. However, they could not part with their palace. Wright provided a reduced version of his design that they could parade across the nation. The Robie Road Abode became a primary vehicle for spreading Wright's popularity throughout the land.

mobile homes
by famous architects

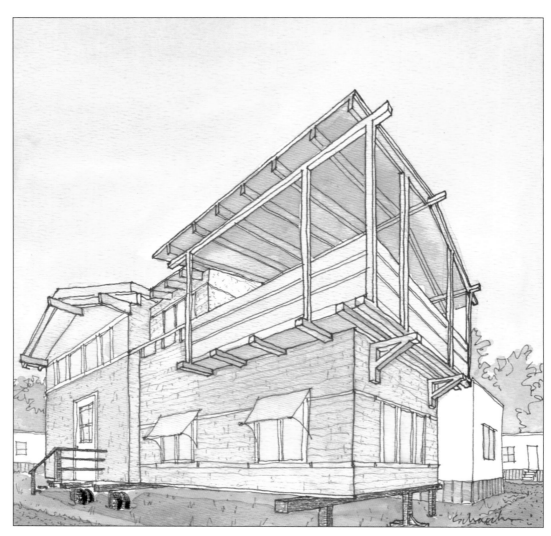

Ramble House

Greene and Greene

CHARLES: BORN 1868, BRIGHTON, OHIO; DIED 1957, CARMEL, CALIFORNIA

HENRY: BORN 1870, BRIGHTON, OHIO; DIED 1954, ALTADENA, CALIFORNIA

Charles and Henry Greene attended the MIT School of Architecture but left early, citing creative differences. They worked in Boston for a time, becoming familiar with Shingle Style architecture. The brothers started their own firm in 1894.

Working together, the Greenes applied qualities of the Shingle Style to the bungalow-style houses of California. Their work was exceptional for its refinement, craftsmanship, and use of regional materials. With articulated surfaces and Oriental sensitivities, the designs became the model for the Arts and Crafts Style. Greene and Greene viewed their works as extensions of the furniture they also designed.

The mobile home industry was in its heyday when Greene and Greene decided to apply their concepts to this exciting new frontier. Their Ramble House had the flexibility to take advantage of different angles of the sun throughout the day, a feature that strongly appealed to the brothers. Their typical attention to detail and the sheer craftsmanship of the Ramble House is an exhilarating departure from the usual mass-produced home. Purchasers were delighted with their ability to impose their natural lifestyle on whomever, wherever they pleased.

mobile homes
by famous architects

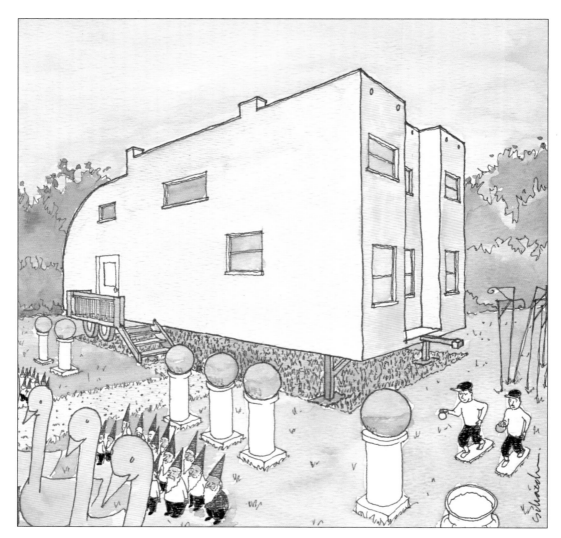

Steiner Yard Ornament Center

Adolf Loos

BORN 1870, BRUNN, CZECHOSLOVAKIA

DIED 1933, KALKSBURG, AUSTRIA

Loos was the son of a stonemason, but he declined to continue the family business. He studied architecture in Dresden and then moved to the United States, where he worked as a mason, floor layer, and dishwasher. Eventually he found work as an architect and opened his own practice in Vienna in 1898.

Loos is better known for his theories of architecture than for his designs. His book *Ornament & Crime* expressed his disgust with Art Nouveau's emphasis on decoration and its rejection of classicism. He believed that beauty should be a product of form and that ornamentation was a sign of moral weakness: "The evolution of culture marches with the elimination of ornament from useful objects."

Astonishingly, Loos's mobile home design is a center for lawn ornaments. It is thought that as he aged, Loos departed from his theories due to his sympathy for the plight of the yard gnomes. As he worked to save them, his passion grew to encompass mirror balls and flamingos.

Loos did continue to leave his facilities unadorned. He justified his acceptance of yard ornaments on the grounds that they were useless items rather than useful ones, and "that makes it OK."

mobile homes
by famous architects

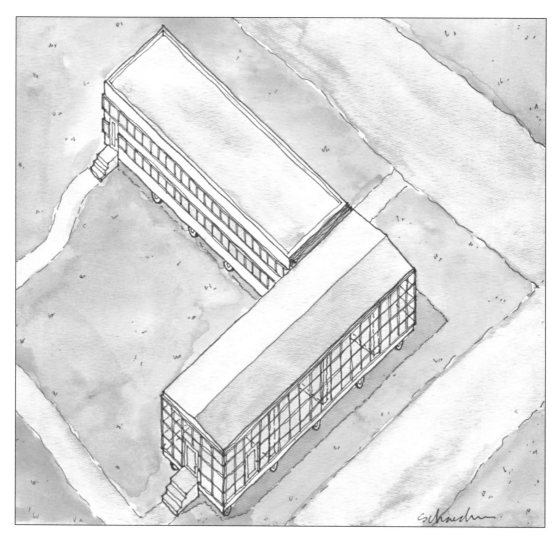

Doppel Möbilhaus

Walter Gropius

BORN 1883, BERLIN, GERMANY

DIED 1969, BOSTON, MASSACHUSETTS

Gropius studied architecture at technical universities in Munich and Berlin. He then worked for Peter Behrens, a notable architect involved with Industrial Modernism. Gropius started his own practice with Adolf Meyer in 1913 and later became the director of the Bauhaus school of design.

The products of the Bauhaus are characterized as High Modernism. Bauhaus combined the antihistorical ideals of architectural theorist William Morris, who felt that art must express man's joy of labor, with machine-age aesthetics and production methods (to which Morris was ardently opposed). Gropius led this modern movement with his development of the curtain wall, which visually lifted buildings free of the ground.

Bauhaus design was so successful throughout the world that Gropius created a caravan-for-design (dee-zann) road tour comprising two trailers expressing the High Modernist design sensibility. The doublewide Doppel Möbilhaus is unconventionally connected at the ends of the homes, creating a pinwheel geometry similar to that found in Bauhaus. Gropius loved the idea of his buildings being mobilized by machines. It is rumored that he changed the "wide load" signs used in transit to read "wide with pride."

mobile homes
by famous architects

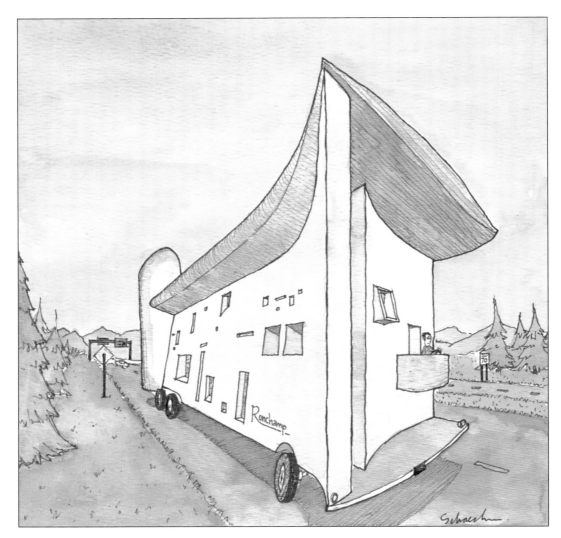

Motor Dame du Haut

Le Corbusier

BORN CHARLES-ÉDOUARD JEANNERET, 1887, LA CHAUX DE FONDS, SWITZERLAND

DIED 1965, CAP MARTIN, FRANCE

A child prodigy later trained as an artist, Jeanneret adopted the name Le Corbusier in the 1920s. He was a leader of High Modernism, combining Classical concepts of form, Futuristic mechanical-morphism, and abstract art. His credo, "a house is a machine for living in," reveals his fascination with the machine age and how it could advance architecture.

Jeanneret cited the automobile industry as a model for his new architecture. However, it is evident that his guiding principles were space and volume within geometric forms. Later his design approach shifted, embracing a more sculptural use of brute concrete. These works were labeled as Brutalism; they evoked primal feelings through their expressionistic shapes and raw textures.

Le Corbusier tried to capture all his theories with one cornerstone project: the Motor Dame du Haut. This, his only vehicle design, truly was a "machine for living in." The motor home borrows from his spectacular church in Ronchamp, France. Actually providing a motor for his design was a pinnacle moment in his career. This elegant conveyance clearly indicates that Le Corbusier's wheels were always turning *towards a new architecture*.

mobile homes
by famous architects

PAGE
33
OF 64 PAGES

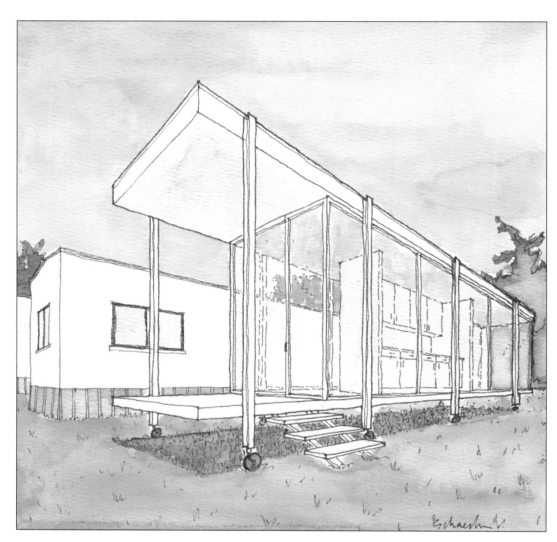

Farnsworth Castered Domicile

REVISIONS	BY

Ludwig Mies van der Rohe

BORN 1886, AACHEN, GERMANY

DIED 1969, CHICAGO, ILLINOIS

Mies worked in the family stonecutting business before he went into architecture. From 1908 to 1912 he worked for Peter Behrens, where he focused on a design approach with a structural emphasis. Although Mies was never formally trained, his career influenced many aspects of architectural theory and practice.

Early in his career, Mies began experimenting with steel structures and glass skins. This experimentation led Minimalism and Rationalism to reach new heights in the world of architecture. His famous assertion that "less is more" is manifest in his designs. Mies believed in simplicity in design through structural integrity and the honesty of materials. His designs were often simple boxes utilizing a steel frame to define space and structure.

Mies's Farnsworth House was revolutionary: glass boxes were unprecedented in residential design. While it was under construction, Mies created a mobile mock house to acclimatize the Farnsworths to their new lifestyle. Clearly different from other mobile homes, the Castered Domicile was used as play equipment by children, who liked to pretend that the horizontals were a biplane's wings. The Farnsworths were grateful that their temporary home was mobile. They are rumored to have moved to thirteen different locations.

mobile homes
by famous architects

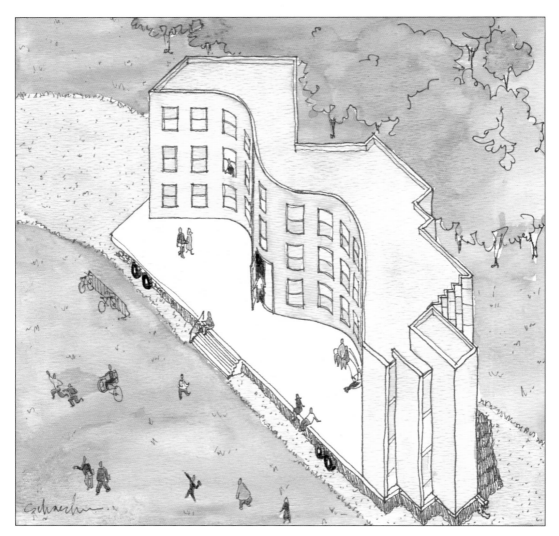

Baker Roamitory

Alvar Aalto

BORN 1898, KUORTANE, FINLAND

DIED 1976, HELSINKI, FINLAND

The son of a surveyor, Aalto graduated with honors from Helsinki Polytechnic and started his own practice soon thereafter. He became a professor of architecture at MIT and was eventually named president of the Academy of Finland.

Aalto's early designs reveal a Neoclassical sensibility. He later embraced the High Modernism led by Le Corbusier and others. However, Aalto transformed the principles of Modernism into his own functionalist/expressionist, humane style. His designs focused on the direct needs of mankind. Employing texture, color, and structure in innovative ways, his designs were unique in material, form, and their response to site.

Aalto had some apprehensions when designing the Baker Roamitory. This facility was part of an MIT outreach program to provide education along the East Coast. Aalto's emphasis on site influencing design was not applicable to this facility, so he created a dual-sided facility that would complement any area. The school has enjoyed much success and recently witnessed the birth of the Iota-Rho fraternity house, commonly called the I-Rolls.

mobile homes
by famous architects

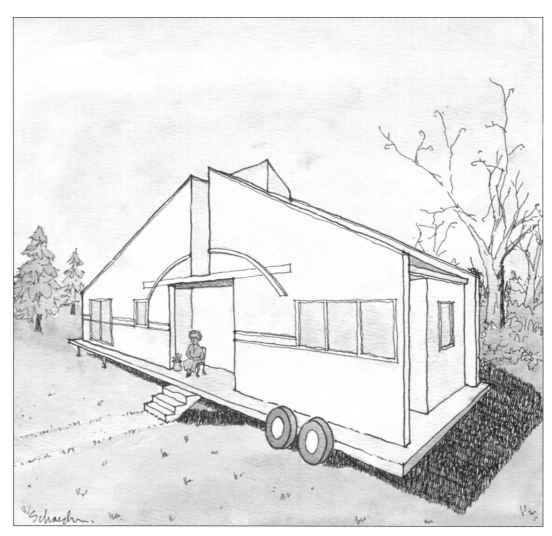

Vanna Venturi Wheeled Ranch

Robert Venturi

BORN 1925, PHILADELPHIA, PENNSYLVANIA

A graduate of Princeton University, Venturi worked with Eero Saarinen and Louis Kahn before starting his own practice in 1958. He took on partners John Rausch in 1964 and Denise Scott Brown (Venturi's wife) in 1967. Venturi has had many notable projects but is best known for his theoretical contributions to architecture.

Venturi wrote *Complexity and Contradiction in Architecture* in 1966. This book focused on a divergence from the simple Modern Style so prevalent at the time. It embraced a "messy vitality over obvious unity." This manifesto and its successor, *Learning from Las Vegas*, influenced many architects with the assertion that architecture should embrace the urban sprawl and concentrate on the decorated shed, using "buildings as billboards," creating a "Pop-architecture."

One of Venturi's most acclaimed early works was a house for his mother. To truly embrace his building-as-billboard concept, he felt it necessary to take this work on the road. Slight modifications to the original design, and installation of some mag wheels, allowed the "wheeled ranch" to be relocated to the center of attention anywhere in the honky-tonk wasteland of the strip that we call home. Ms. Venturi was fine with the incessant parading of her son's work, as long as she had her porch to sit on.

mobile homes
by famous architects

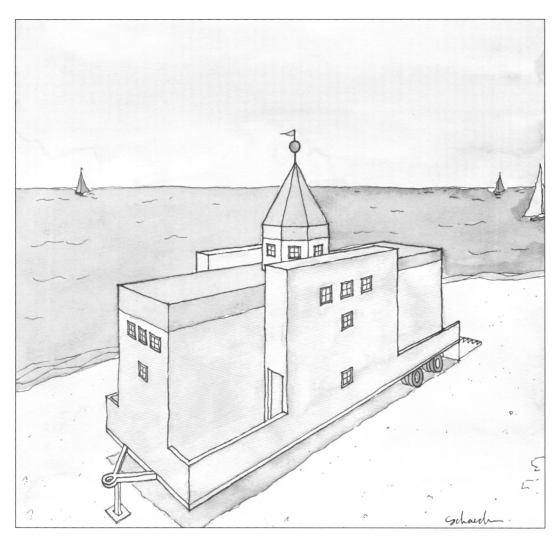

Il Trailer del Mondi

Aldo Rossi

BORN 1931, MILAN , ITALY

DIED 1997, ITALY

Rossi received his architectural degree from Milan Polytechnico in 1959. His early aspiration was to work in film; he maintained his link to the theater in his architecture. Rossi taught at several architectural schools, and he became a well-known theorist with the publication of *Architecture and the City,* a book about urban design and thinking.

Following classical principles but not copying them, Rossi's designs are often bold, simple forms, yet they are complex in meaning. Rossi often took traditional architectural models and reduced the masses to their simplest forms, providing a condensed—often haunting—image of the building.

Rossi's best-known work is his Teatro del Mondo, a floating theater on the canals of Venice. Seeking to duplicate the theater's successful effects, Rossi re-created it in trailer form. Il Trailer del Mondi has become a huge success, primarily because its bold simplicity attracts ordinary people as well as architectural cognoscenti. To amplify the eerie effects often found in his designs and play up the faux theater's drama, Rossi hid an engine in the facility. This engine periodically starts and stops on its own, creating tension and confusion among those inside because they realize that they are in a trailer—which should have no engine.

mobile homes
by famous architects

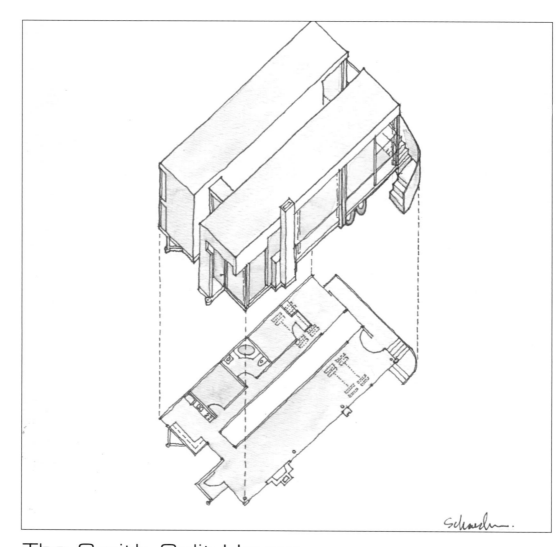

The Smith Split-House

Richard Meier

BORN 1934, NEWARK, NEW JERSEY

Meier studied architecture at Cornell University and then worked with several architects, including Skidmore, Owings & Merrill and Marcel Breuer. He started his own practice in 1963 and became one of the New York Five—architects who advocated Modernist principles. Meier went on to receive the Pritzker Prize in 1984.

Consistently adhering to purist modern principles, primarily those of Le Corbusier, Meier's buildings are typically white, with a pure geometry that allows spaces to be defined by light. These designs often look high-tech and ultraclean. The layouts for his facilities follow a poetic logic that interplays between geometric forms.

Meier maintained the purity of the mobile home module, and that of Modernism, because he managed to combine two trailers but keep them separate. For The Smith Split-House, he offered the following:

The mobile home is pure Modernism in motion
Light-defined space overlooking the hills or ocean,
Geometry that undeniably fits the house,
Functionality enough to impress your spouse,
Its orientation can affect its space and lighting,
If you have no level ground, life here will be exciting.

Poetic logic indeed.

mobile homes
by famous architects

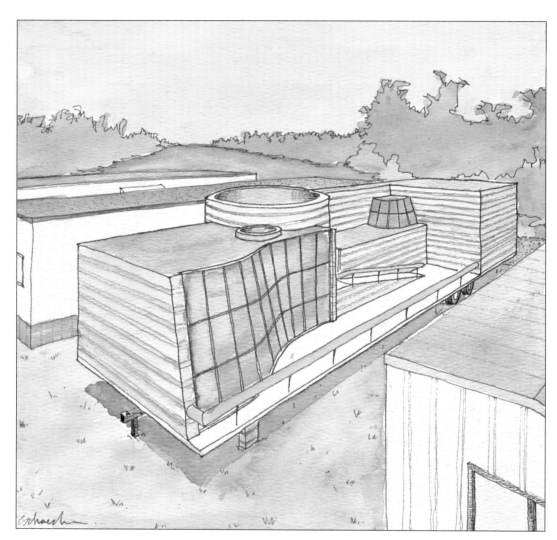

Neue Haustrailerie

James Stirling

BORN 1926, GLASGOW, SCOTLAND

DIED 1992, LONDON, ENGLAND

Stirling studied architecture at Liverpool University and worked for Lyons, Israel, and Ellis in London for several years. He later started his own practice with James Gowan. Stirling was honored with the Pritzker Prize in 1981.

Early works by Stirling stressed the idea of concept over aesthetic and utility. Indicating influence from Le Corbusier, Stirling's buildings started a trend toward the use of brick and exposed concrete. Later in his career, Stirling's approach became more sympathetic to the Postmodernist style. His approach to design always seemed experimental, and a classification of style did not seem to apply.

Stirling's design for a mobile home was no exception to his experimental methods. With vibrant striping and undulating windows, his home (he did reside in it for several years) grabs the attention of even the most oblivious trailer observer. He designed the Neue Haustrailerie so that it could be appreciated when being transported on the highway by making it a complex grouping of masses with reflective areas. The home proved to be a traveling hazard, however: rubbernecking drivers were blinded by the sun's reflection off the windows, and a few accidents occurred.

mobile homes
by famous architects

Trailer Jarts

SITE

FOUNDED 1970

James Wines, born 1932 in Chicago, Illinois, collaborated with Alison Sky and Michelle Stone to form the design group SITE (Sculpture in the Environment) in 1970. Their work attracted plentiful public attention because of its wit and irony. SITE's buildings are often located in typical urban sprawl developments that need to attract the motorized consumer to the oversized warehouse.

SITE's series of projects for Best Products were well received for their humor and unconventionality. The Tilt showroom has the structure's facade detached from its mass but leaning on it. Another project, titled Notch, raggedly detaches a large corner of the warehouse and places it across the parking lot. The novelty of these designs has succeeded in attracting customers and attention.

In many ways the trailer park is similar to the strip mall, with its repetition and loss of individuality. SITE's approach to the trailer park again attracts attention and surprise. It is believed that SITE installed the work itself. Deploying two oversized cranes on each side of the park, the firm conducted an actual game of Jarts with the trailers. SITE insisted that designing the locations for the trailers would have seemed contrived, and besides, the winner would receive a case of beer from the losers.

mobile homes
by famous architects

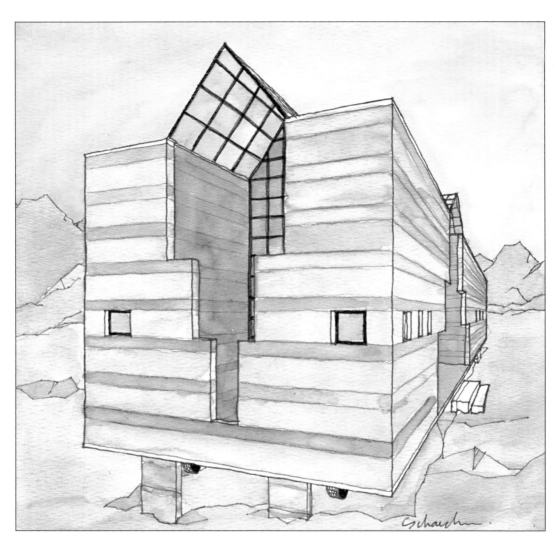

Casa Mobilino

Mario Botta

BORN 1943, MENDRISIO, SWITZERLAND

Botta trained as a technical draftsman before studying at the Liceo Artistico in Milan. He then studied architecture at the Instituto Universitario di Architecttura in Venice; during this time, he worked for Le Corbusier and Louis Kahn. Botta opened his own practice in 1970. His works are primarily houses located in the mountains of Switzerland, although he has recently produced work in the United States.

In designs that concentrate on the layering of textures, colors, materials, and elements, often in simple geometric forms, Botta strives for an architecture that works with the environment rather than technology and the machine. His works often slam together contradictory elements, such as circle and square, void and solid, big and small.

Botta designed one of the few mobile homes (if not the only one) of the Alps. Equipped with chains on its wheels and four-wheel-trail capability, the Casa Mobilino is designed to travel anywhere a ski lift can reach. The facility's stark geometry and rich colors complement its picturesque surroundings. Botta has succeeded once again with a design that manages to roll forward from the shadows of the Swiss abyss.

mobile homes
by famous architects

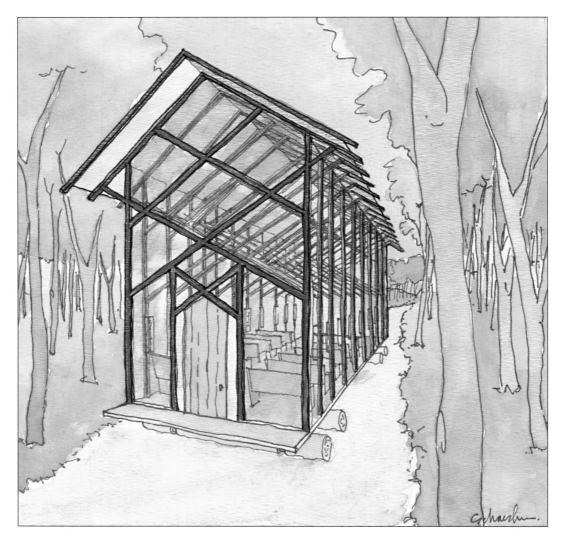

Thorncrown Quad-Axle Chapel

E. Fay Jones

BORN 1921, ARKANSAS

DIED 2000, ARKANSAS

Jones studied architecture at the University of Arkansas and Rice University in Texas. He apprenticed with Frank Lloyd Wright and then started his own practice in Arkansas. He was awarded the American Institute of Architects Gold Medal in 1990.

Jones's works display a contextualism and regionalism that can be attributed to his stint with Wright. Providing his own aesthetic interpretation of form, Jones's designs rely on a simple, repetitive, exposed structure that blends with its surroundings but also sets itself apart. The majority of his works are small projects found in the hills of Arkansas.

One example of Jones's Arkansas work is the Thorncrown Quad-Axle Chapel, which has caught the eye of nearly every backwoodsman in the Ozarks. Originally, the church proposed placing loudspeakers on the building and blaring "Dueling Banjos" to attract worshipers. However, Jones persuaded them to let the design be the beacon; it also exceeded all expectations. However, blending in with its surroundings has resulted in the chapel being misplaced when the pastor has been "called to nature."

mobile homes
by famous architects

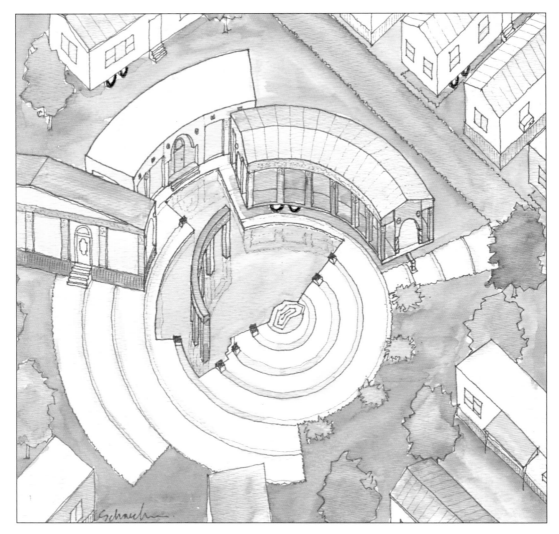

Piazza d'Oublewide

Charles Moore

BORN 1925, BENTON HARBOR, MICHIGAN

DIED 1993

Moore graduated from the University of Michigan in 1947. He served with the Army Corps of Engineers in the Korean War and then continued his architectural studies, earning a doctorate at Princeton University. Moore taught during much of his career, but he also managed to practice with the firm MLTW.

Regarded as one of the pioneers of Postmodern architecture, Moore focused on the relationship between the building and its physical and historical context. He introduced elements of whimsy and satire into his designs and stressed the juxtaposition of unrelated forms, producing stimulating environments.

Moore's design for the Piazza d'Oublewide engages the myth and history of the trailer park. Criticized heavily for the use of curved trailers that can be moved around only in a circle, Moore defied the conventions of the typical trailer, much as he did those of Modernism. His Piazza, the park's cultural center, has been heralded by park inhabitants as a "great place to sit back and watch the weeds grow under our homes." Another successful example of Postmodernism.

mobile homes
by famous architects

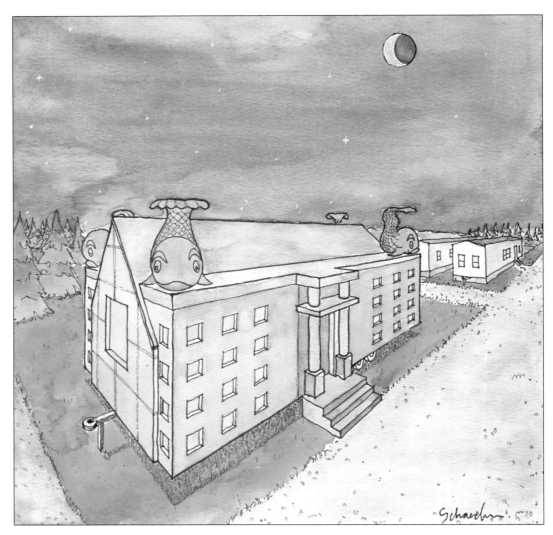

Dolphin Doublewide

Michael Graves

BORN 1934, INDIANAPOLIS, INDIANA

After attending the University of Cincinnati and Harvard University, Graves worked as a Fellow of the American Academy in Rome for two years. He started his own practice in Princeton in 1964 and became a professor at Princeton University in 1972.

Graves's work reflects his interpretation of classical architecture in today's materials, synthesizing contemporary and traditional stylings. His designs consistently reveal his emphasis on addressing the context of their surroundings. Graves has become one of the most recognizable names in architecture, not only because of his identifiable building designs, but also because of his unique designs of everyday items such as clocks, teapots, and picture frames, which are available to the public through popular marketplaces.

Graves is not shy about designing mobile homes, either. Coming off the success of his Dolphin and Swan Hotels for Disney, Graves used a similar theme to enliven the concept of "the park" and to add some whimsy. Brightly colored and magnificently proportioned, the design marks him as one who can design anything successfully. These homes can't keep up with their demand. The slogan for the homes is "Swimsy with the Dolphin Doublewide."

mobile homes
by famous architects

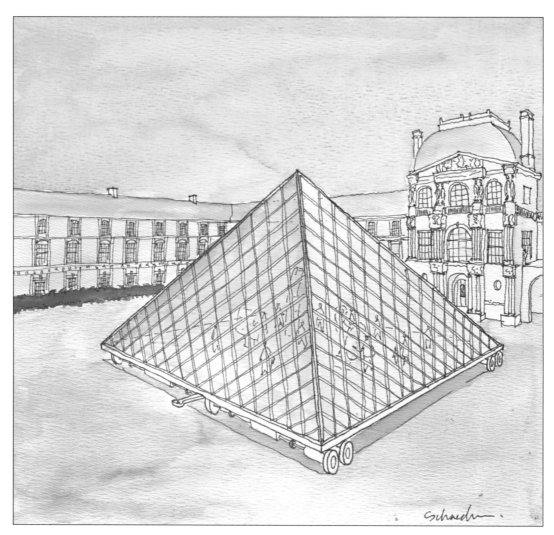

Pyramid du Trailevre

I. M. Pei

BORN 1917, CANTON, CHINA

Ieoh Ming Pei left China at the age of eighteen to study architecture at MIT and Harvard University. He was a concrete designer for Stone and Webster and then an instructor and assistant professor at Harvard University before going to work at Webb & Knapp in 1948, where he became head of the architectural division. Pei started his own firm in 1960.

Pei's designs typically utilize abstract forms in stone, concrete, glass, and steel in sharp geometries. Even though some designs seem Gropius-like, Pei does not concern himself with deep theory. Nor does he believe that work should relate to societal trends or be isolated from commercialism.

One of Pei's most notable achievements is his design for the Louvre. As a practical joke, Pei provided the Louvre with an additional gallery, the Pyramid du Trailevre. This gallery attracts unsuspecting visitors just like the others. However, the museum staff will wheel this trailer away and drop off its visitors at a camp operated by the French Foreign Legion, where they will be required to train for one week. The visitors are not allowed back into the Louvre until they say, "I. M. Pei, you are funnay."

mobile homes
by famous architects

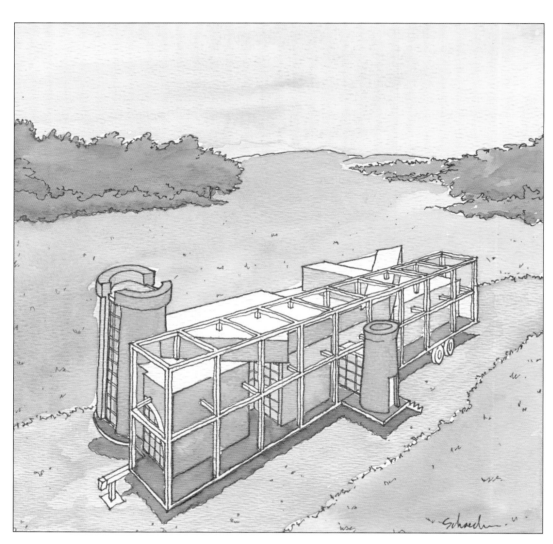

Wexner Renter

Peter Eisenman

BORN 1932, NEWARK, NEW JERSEY

Eisenman studied architecture at Cornell and Columbia Universities and then at Cambridge University in England. He has taught at Cambridge, Princeton University, and Cooper Union, where he was the founding director of the Institute for Architecture and Urban Studies. He was also the leader of the New York Five group, committed to providing theory and discourse about architecture.

Having had fewer works built than he has had published, Eisenman writes about his projects in a pretty heady style; one can easily get lost in his rhetoric. His theories focus on creating an architecture that is disconnected from context and relates to its own space. They seek to connect to his pursuit of philosophical or literary theory. His works are "antihumanist," relating only to their arbitrary pursuits of form. The success of their function is of secondary importance.

His mobile home exhibits Eisenman's pursuit of literary theory. He does, however, acknowledge some indication of function by relating to the literary works of the Enlightenment philosopher René Descartes. A team of twelve experts examined magazine articles supporting the design of the Wexner Renter for a period of two weeks. After this study, Eisenman chose Descartes because the last syllable of his name kind of relates to a mobile home, in an esoteric, existential sense.

mobile homes
by famous architects

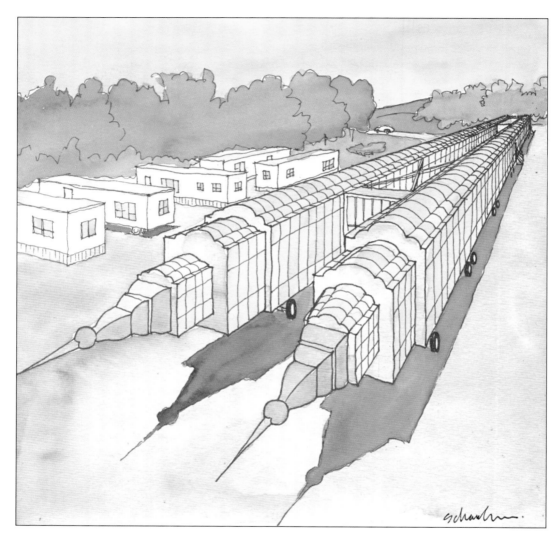

Petronas Trailers

Cesar Pelli

BORN 1926, TUCUMAN, ARGENTINA

Pelli received his master's degree in architecture and then worked ten years in Eero Saarinen's office. He became a design partner at Gruen Associates in Los Angeles before starting his own practice in 1977. From 1977 to 1984 he served as dean of the School of Architecture at Yale University.

A designer who uses a multitude of materials and designs, Pelli notes that his works should be viewed as "responsible citizens" which work within the context of the surrounding city. Pelli has designed many different building types, from homes to skyscrapers. He stresses the importance of evaluating each project individually to determine the best materials and forms for its purpose and context.

Pelli is responsible for the design of the world's tallest buildings, the Pentronas Towers in Kuala Lumpur. When approached about designing a mobile home, Pelli felt that the appropriate solution would be a horizontal version of his towers. Clearly demonstrating his notion of "responsible citizens," this design blends well with its context. The Petronas Trailers have been moved twice from their current location. Street traffic was detoured up to five miles away to provide proper turning radii for the trailers.

mobile homes
by famous architects

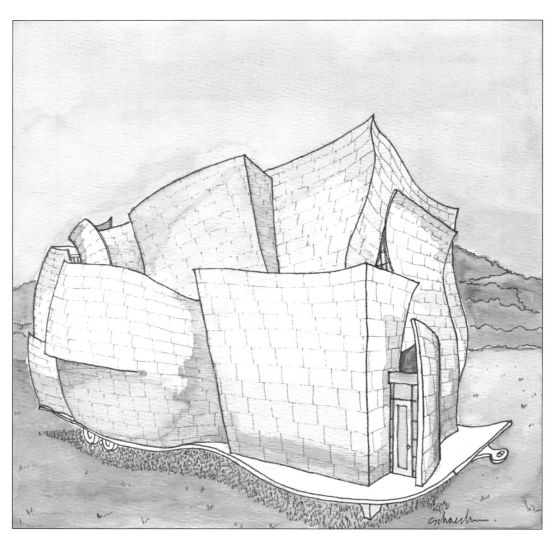

Guggenheim Cruise-Seum

Frank O. Gehry

BORN 1929, TORONTO, ONTARIO

Gehry studied architecture at the University of Southern California and Harvard University. He established his own practice in 1963, which was succeeded in 1979 by Gehry & Krueger, Inc. His recent projects have achieved much notoriety in the public eye, giving him superarchitect stature throughout his profession.

Architecture, Gehry believes, is a progressive art form that should address the present and the future and reject imitation of the past. It is also an artistic endeavor that should revolve around the possibilities of unexplored shapes and untried materials. Gehry's recent works have exhibited an unrestrained freedom, utilizing undulating curves and exquisite building materials that are unmatched in today's society.

The success of Gehry's design for the Guggenheim Museum in Bilbao, Spain, prompted the Guggenheim to create a traveling version. Utilizing sheet titanium—as Gehry did for the building— has proven to be a mistake with this project, however. The acids from insects splattering on the facility while in transit have stained the panels and, in some locations, deteriorated them. Gehry is currently designing a bug shield and curb feelers for the Guggenheim Cruise-Seum.

mobile homes
by famous architects

Bibliography

Emmanuel, Muriel. *Contemporary Architects*. New York: St. Martin's Press, 1980.

Frampton, Kenneth. *Modern Architecture: A Critical History*. London: Thames and Hudson, 1980, 1985.

http://architecture.about.com/library/bl-pelli.htm, © About.com 2001.

Hyman, Isabelle and Marvin Trachtenberg. *Architecture: From Prehistory to Post-Modernism*. New York: Harry N. Abrams B.V., 1986.

Placzek, Adolf K. *Macmillan Encyclopedia of Architects*. Vol. 3. London: The Free Press, 1982.

Raeburn, Michael. *Architecture of the Western World*. Orbis Publishing Limited, 1980.

Sharp, Dennis. *The Illustrated Encyclopedia of Architects and Architecture*. New York: Quatro, 1991.

Stern, Robert A. M. *Modern Classicism*. New York: Rizzoli International Publications, 1988.

Van Vynckt, Randall J. *International Dictionary of Architects and Architecture: Volume 1–Architects*. London: St. James Press, 1993.

Whiffen, Marcus and Frederick Koeper. *American Architecture 1860–1976*. Cambridge: Massachusetts Institute of Technology, 1981.

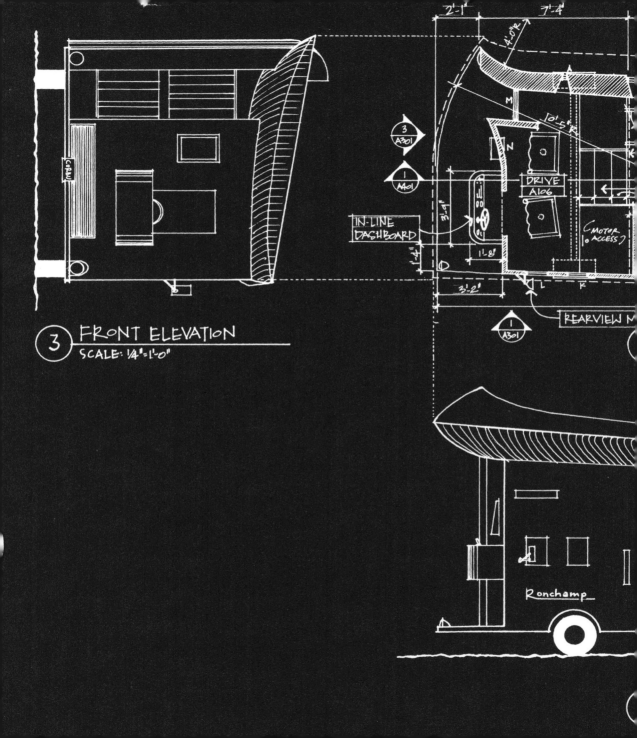

CRAWL

IN-LINE
DASHBOARD

3
A301

1
A301

M

N

DRIVE
A106

MOTOR
ACCESS

2'-1"

7'-4"

4'-0" R

10'-5" R

3'-9"

1'-8"

3'-2"

D

L

K

1
A301

REARVIEW M

③ FRONT ELEVATION
SCALE: 1/4"=1'-0"

Ronchamp